Draw in
PENCIL
CHARCOAL, CRAYON & OTHER MEDIA

Hans Schwarz

Series Editors: David and Brenda Herbert

A & C BLACK · LONDON

Reprinted 1982, 1984, 1986, 1988, 1989, 1992
by A & C Black (Publishers) Ltd
35 Bedford Row, London WC1R 4JH

ISBN 0-7136-2252-0

First published 1980
by Pitman Publishing Ltd

Text set in VIP Palatino
Printed and bound in Great Britain
by Hollen Street Press Ltd, Slough, Berkshire

Contents

Making a start

Learning to draw is largely a matter of practice and observation—so draw as much and as often as you can, and use your eyes all the time.

Look around you—at chairs, tables, plants, people, pets, buildings, your hand holding this book. Everything is worth drawing. The time you spend on a drawing is not important. A ten-minute sketch can say more than a slow, painstaking drawing that takes many hours.

Carry a sketchbook with you whenever possible, and don't be shy of using it in public, either for quick notes to be consulted later or for a finished drawing.

To do an interesting drawing, you must enjoy it. Even if you start on something that doesn't particularly interest you, you will probably find that the act of drawing it—and looking at it in a new way—creates its own excitement. The less you think about *how* you are drawing and the more you think about *what* you are drawing, the better your drawing will be.

The best equipment will not itself make you a better artist a masterpiece can be drawn with a stump of pencil on a scrap of paper. But good equipment is encouraging and pleasant to use, so buy the best you can afford and don't be afraid to use it freely.

Be as bold as you dare. It's your piece of paper and you can do what you like with it. Experiment with the biggest piece of paper and the boldest, softest piece of chalk or crayon you can find, filling the paper with lines—scribbles, funny faces, lettering, anything—to get a feeling of freedom. Even if you think you have a gift for tiny delicate line drawings with a fine pen or pencil, this is worth trying. It will act as a 'loosening up' exercise. The results may surprise you.

Be self-critical. If a drawing looks wrong, scrap it and start again. A second, third or even fourth attempt will often be better than the first, because you are learning more about the subject all the time. Use an eraser as little as possible—piecemeal correction won't help. Don't re-trace your lines. If a line is right the first time, leave it alone—heavier re-drawing leads to a dull, mechanical look.

Try drawing in colour. Dark blue, reddish-brown and dark green are good drawing colours. A coloured pencil, pen or chalk can often be very useful for detail, emphasis or contrast on a black and white drawing: for instance, in a street scene, draw the buildings in black, the people, car, etc. in another colour. This simple technique can be very effective.

You can learn a certain amount from copying other people's drawings. But you will learn more from a drawing done from direct observation of the subject or even out of your head, however stiff and unsatisfactory the results may seem at first.

A lot can be learned by practice and from books, but a teacher can be a great help. If you get the chance, don't hesitate to join a class—even one evening a week can do a lot of good.

Perspective

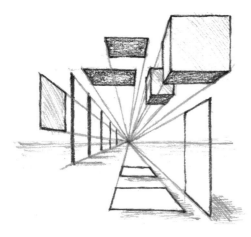

You can be an artist without knowing anything about perspective. Five hundred years ago, when some of the great masterpieces of all time were painted, the word did not even exist. But most beginners want to know something about it in order to make their drawings appear three-dimensional rather than flat, so here is a short guide.

The further away an object is, the smaller it seems.

All parallel horizontal lines that are directly opposite you, at right-angles to your line of vision, remain parallel.

All horizontal lines that are in fact parallel but go away from you will appear to converge at eye-level at the same vanishing point on the horizon. Lines that are *above* your eye-level will seem to run downwards towards the vanishing point; lines that are *below* your eye-level will run upwards. You can check the angles of these lines against a pencil held horizontally at eye-level.

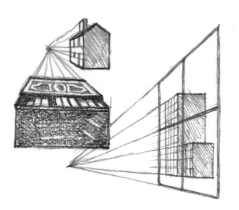

The larger and closer any object is, the bigger the front of it will seem to be in relation to the part furthest away, or to any other more distant object. Its actual shape will appear foreshortened or distorted. A matchbox close to you will appear larger and more distorted than a distant house, and if you are drawing a building seen at an angle through a window, the window frame will be larger and more distorted than the building.

If the side of an object is facing you one vanishing point is enough (as in the matchbox drawing); but if the corner is facing you, two vanishing points will be needed.

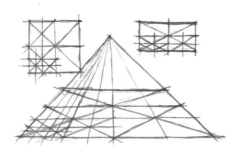

It may even be necessary to use three vanishing points when your eye is well above or below an object, but these occasions are rare.

Diagonal lines drawn between the opposite angles of a square or rectangle will meet at a point which is half-way along its length or breadth. This remains true when the square or rectangle is foreshortened. You may find it helpful to remember this when you are drawing surfaces with equal divisions—for example, a tiled floor or the divisions between window panes—or deciding where to place the point of a roof or the position of windows on a façade.

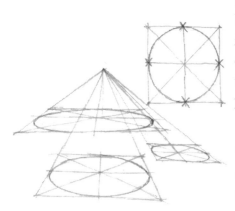

When drawing a circular shape, the following is useful: a square drawn round a circle will touch the circle at the centre point of each of its sides. A foreshortened circle will turn into an oval, but will still

touch the centre points of each side of a similarly foreshortened square. However distorted the square, the circle will remain a true oval but will seem to tilt as the square moves to left or right of the vanishing point. The same is true of half circles.

Here are a few common mistakes and how to sort them out yourself. Most beginners will draw a cube, a chair, a table like this:

You will tend to exaggerate the apparent depth of top surfaces because you know they are square or rectangular and want to show this in your drawing.

You can check the correct apparent depth of any receding plane by using a pencil or ruler held at eye-level and measuring the proportions on it with your thumb. If you use a ruler you can actually read off the various proportions.

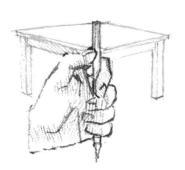

The same applies when you are drawing figures. If, for example, you try to draw a foreshortened forehead or arm you will tend to draw it the shape you know it to be rather than the shape it appears to be from your viewpoint. Again, measuring one proportion against another will help you to make your drawing look right.

One point to mention again: *all* receding parallel lines have the same vanishing point. So if, for instance, you draw a street this will apply to all the horizontal edges—roofs, doors, windows, lines of bricks, chimneys.

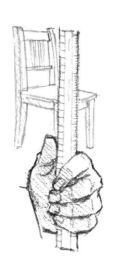

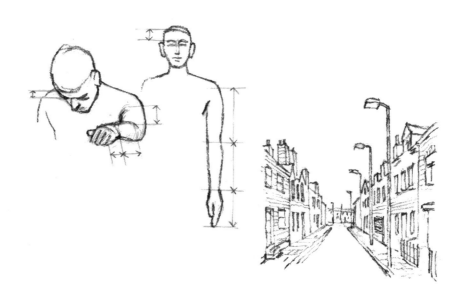

Composition

Deciding where to place even the smallest sketch or doodle on a scribbling pad involves composition. It is generally best to make your drawing as large as possible on your piece of paper. But there are many possibilities. Sometimes you may not even want the whole of the object on your paper. And there is no reason why the paper should be the same shape as the subject—it is not, for instance, necessary to draw a tall object on an upright piece of paper.

When you are drawing more than one object on a sheet of paper, the placing of each object is also important. Try as many variations as possible.

Before you begin a drawing, think about how you will place it on the paper—even a few seconds' thought may save you having to start your drawing again. One of the most common mistakes in figure drawing is to start by putting the head in the centre of the paper, regardless of which way the body goes. *Never* distort your drawing in order to get it all in, or you will end up with a short-legged figure or a short-bodied dachshund and wonder why it looks wrong.

Before starting an elaborate drawing, do a few very rough sketches of the main shapes to help you decide on the final composition. When you have decided which to use, rule a faint network of lines—diagonal, vertical and horizontal—over this preliminary sketch and on the piece of paper to be used for the finished drawing. (Take care that both pieces of paper are the same proportion.) You will then have a number of reference points to enable you to transfer the composition to the final drawing.

Rules are made to be broken. Every good artist is a good artist at least partly because of his originality; because he does what no one else has done before and because he breaks rules.

Every human being is unique. However poor an artist you *think* you are, you are different from everyone else and your drawing is an expression of your self.

What to draw with

Pencils are graded according to hardness, from 6H (the hardest) through 5H, 4H, 3H, 2H to H; then HB; then B, through 1B, 2B, 3B, 4B, 5B up to 6B (the softest). For most purposes, a soft pencil (HB or softer) is best. If you keep it sharp, it will draw as fine a line as a hard pencil but with less pressure, which makes it easier to control. Sometimes it is effective to smudge the line with your finger or an eraser, but if you do this too much the drawing will look woolly. Pencil is the most versatile of all drawing techniques, suitable for anything from the most precise linear drawing to broad tonal treatment. Of course, a pencil line, even at its heaviest, is never a true black. But it has a lustrous, pewtery quality that is very attractive.

Charcoal can be bought in various qualities and sizes. I advise short sticks since they are cheaper, and long sticks soon break into short sticks anyhow.

Charcoal (which is soft and crumbly) is ideal for bold, large drawings. But beware of accidental smudging. Never rest your hand on the paper as you draw. If you are used to pen or pencil this may at first seem difficult. But you will soon get used to it and, once you do, will find it adds freedom and spontaneity to your work.

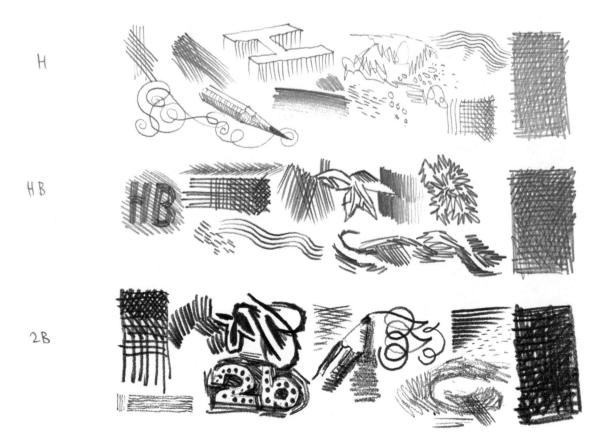

H

HB

2B

It is the most painterly of all drawing instruments. Smudging and erasing charcoal (tradionally done with kneaded pellets of bread) will give far more variety of texture than on a pencil drawing. And any part of the drawing you don't like can be removed with the flick of a rag. Take great care to preserve your successful drawings—by fixing them with a spray fixative (now universally sold in Aerosol cans), and by attaching to them an overlay of tissue paper.

Conté crayons, wood-cased or in solid sticks, are available in various degrees of hardness, and in three colours—black, red and white. The cased crayons are easy to sharpen, but the solid sticks are more fun— you can use the side of the stick for large areas of tone. Conté is harder than charcoal, but it is also easy to smudge. The black is very intense.

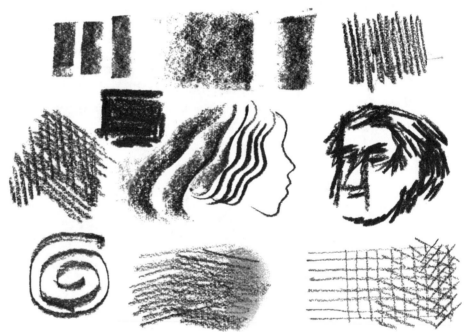

Reed, bamboo and quill pens are good for bold lines. You can make the nib end narrower or wider with the help of a sharp knife or razor blade. This kind of pen has to be dipped frequently into the ink.

Fountain pens have a softer touch than dip-in pens, and many artists prefer them. The portability of a fountain pen makes it a very useful sketching tool.

Special fountain pens, such as Rapidograph and Rotring, control the flow of ink by means of a needle valve in a fine tube (the nib). Nibs are available in several grades of fineness and are interchangeable.

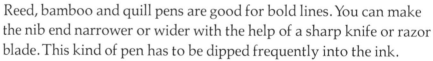

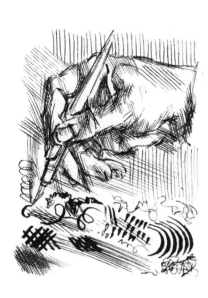
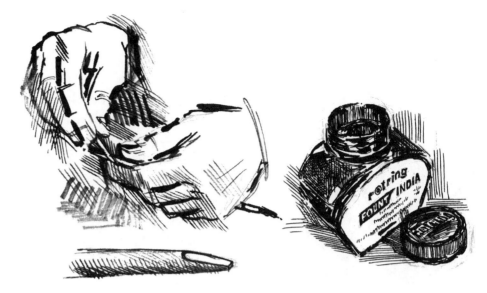

The line they produce is of even thickness, but on coarse paper you can draw an interesting broken line similar to that of a crayon. These pens have to be held at a right-angle to the paper, which is a disadvantage.

Inks also vary. Waterproof Indian ink quickly clogs the pen. Pelikan Fount India, which is nearly as black, flows more smoothly and does not leave a varnishy deposit on the pen. Ordinary fountain-pen or writing inks (black, blue, green or brown) are less opaque, so give a drawing more variety of tone. You can mix water with any ink in order to make it even thinner. But if you are using Indian ink, add distilled or rain water, because ordinary water will cause it to curdle.

Ball point pens make a drawing look a bit mechanical, but they are cheap and fool-proof and useful for quick notes and scribbles.

Fibre pens are only slightly better, and (whatever the makers say) their points tend to wear down quickly.

Felt pens are useful for quick notes and sketches, but not good for more elaborate and finished drawings.

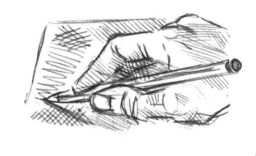

Brushes are most versatile drawing instruments. The Chinese and Japanese know this and until recently never used anything else, even for writing. The biggest sable brush has a fine point, and the smallest brush laid on its side provides a line broader than the broadest nib. You can add depth and variety to a pen or crayon drawing by washing over it with a brush dipped in clean water.

Mixed methods are often pleasing. Try making drawings with pen and pencil, pen and wash, charcoal and wash, or Conté and wash. And try drawing with a pen on wet paper. Pencil and Conté do not look well together, and Conté will not draw over pencil or any greasy surface.

Above all, experiment with different techniques, on various qualities and surfaces, even if you quickly find a favourite way of doing things. A new technique will force you to vary the scale of your work and thus see it differently. A small circle, for example, looks different from a large one.

What to draw on

Try as many different surfaces as possible.

Ordinary, inexpensive paper is often as good as anything else: for example, brown and buff wrapping paper (Kraft paper) and lining for wallpaper have surfaces which are particularly suitable for charcoal and soft crayons. Some writing and duplicating papers are best for pen drawings. But there are many papers and brands made specially for the artist.

Bristol board is a smooth, hard white board designed for fine pen work.

Ledger Bond ('cartridge' in the UK) the most usual drawing paper, is available in a variety of surfaces—smooth, 'not surface' (semi-rough), rough.

Watercolour papers, also come in various grades of smoothness. They are thick, high-quality papers, expensive but pleasant to use.

Ingres paper is mainly for pastel drawings. It has a soft, furry surface and is made in many light colours—grey, pink, blue, buff, etc.

Sketchbooks, made up from nearly all these papers, are available. Choose one with thin, smooth paper to begin with. Thin paper means more pages, and a smooth surface is best to record detail.

Lay-out pads make useful sketchbooks. Although their covers are not stiff, you can easily insert a stiff piece of card to act as firm backing to your drawing. The paper is semi-transparent, but this can be useful— almost as tracing paper—if you want to make a new improved version of your last drawing.

An improvised sketchbook can be just as good as a bought one— or better. Find two pieces of thick card, sandwich a stack of paper, preferably of different kinds, between them and clip together at either end.

Different techniques shown in a single drawing

Textured paper
Paper with such coarse texture
is only suitable for very free
and large drawings.
Charcoal

Kent paper H pencil

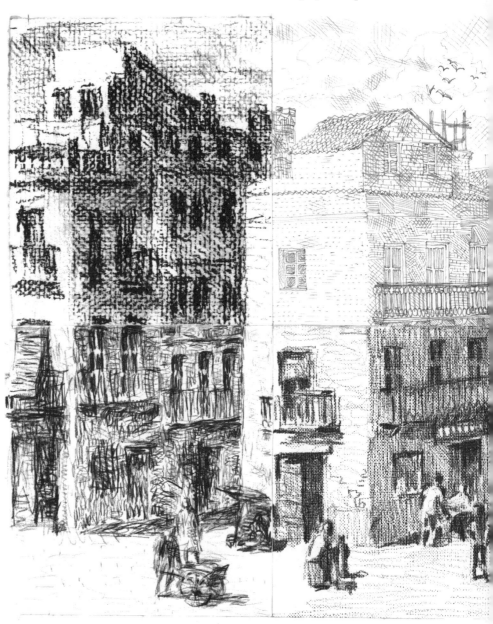

Kent dry paper Woodcased crayon

Linen textured paper
Chinagraph pencil

Ribbed paper Conté crayon Kent paper 4 B pencil

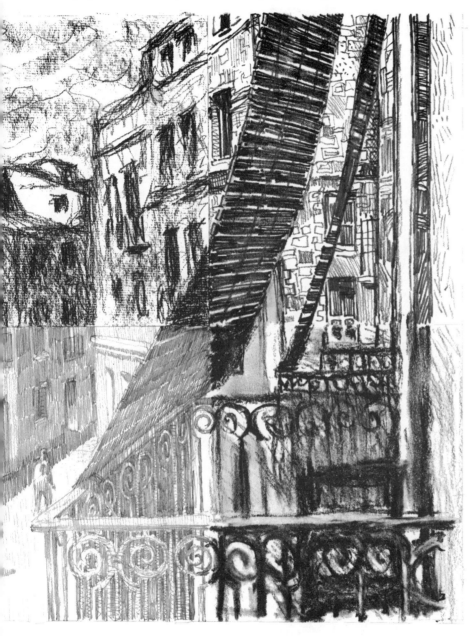

Kent paper HB pencil Kent paper Charcoal

Drawing by stages: Conté no4

From its first few lines onwards, a drawing ought to look complete. Work all over your drawing. Don't finish one part before others have reached an advanced stage. There are artists who successfully paint and draw detail by detail—rather like embroiderers—but they are exceptional.

1. Laying down the basic shape. Even at such an early stage you should indicate the most important areas of tone.

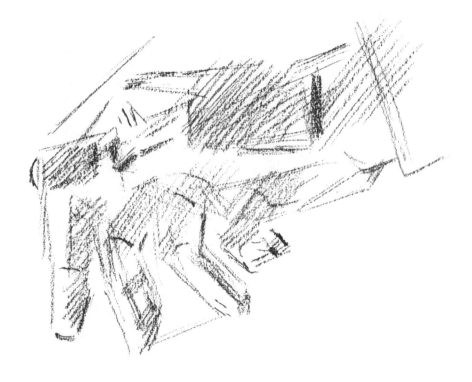

2. Blocking in the main areas of tone, refining the drawing.

3. Deepening the tone, bringing some of it to full strength. By stressing the darkest tones and emphasising important parts of the drawing—the finger and the thumb joints—the drawing has lost unity. The heavy blacks become over-insistent.

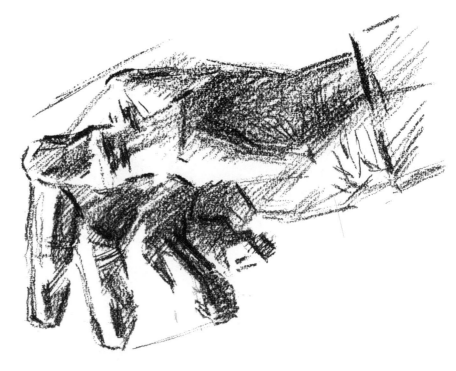

4. The finished drawing. Further shading unifies the drawing. Varying the direction of shading adds solidity and interest. Background tone brings out the highlights on the hand.

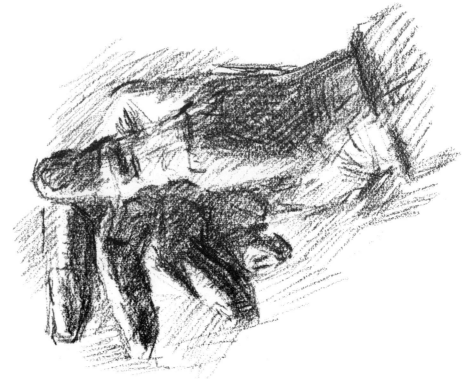

Drawing by stages: 4B pencil

1. From the beginning, the main element of the drawing—the arm-chair—needs to be placed in its setting, with carpet, curb, jug and ship in case included. Objects don't exist in isolation. Even something placed on a white piece of paper will throw a shadow onto it. Tone also needs indicating in the background.

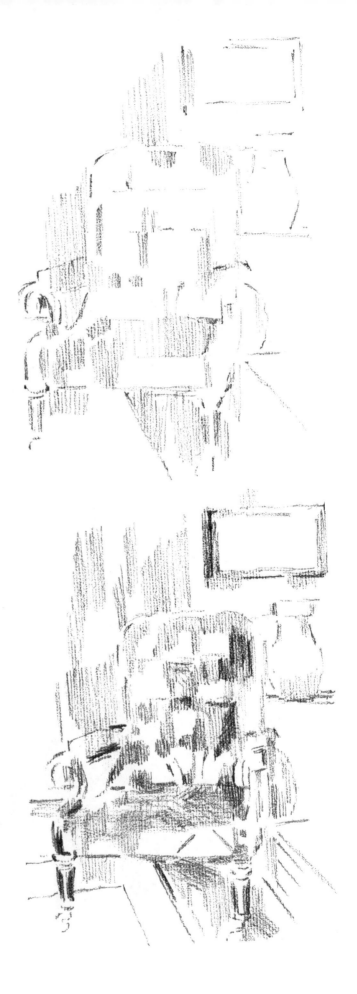

2. Tone is elaborated. The first dark areas are drawn.

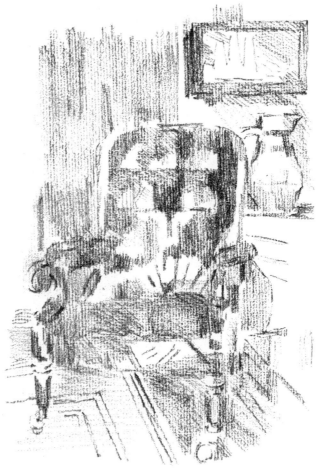

3. The patchiness of the previous stage is removed by simplifying the shading. Smaller details appear—jug, carpet, ship in case.

4. Delicate details are added; carpet pattern, sails and rigging on the ship, upholstery nails. Even if these are the kind of thing that first make you wish to draw a picture, resist the temptation to begin with them. Save the tit-bits. It is the big shapes that matter most in a drawing.

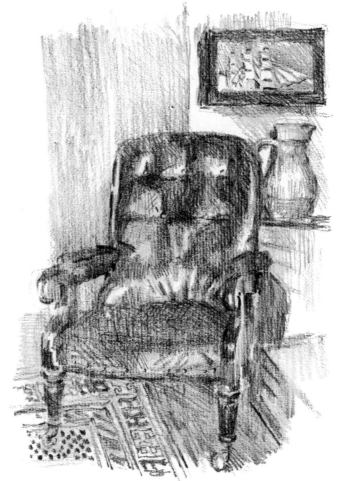

Drawing by stages: Charcoal

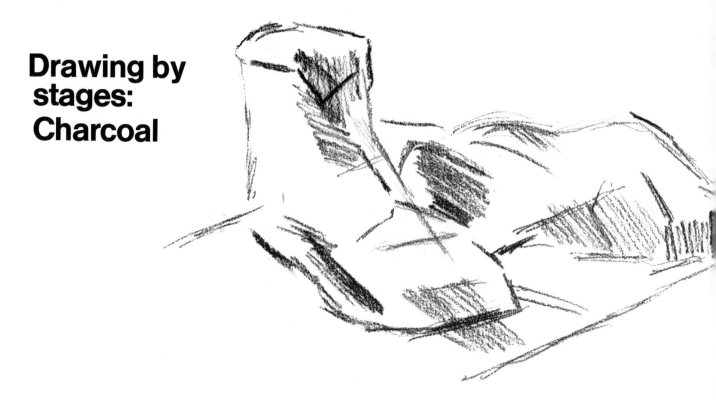

1. Here again main lines and tones come first. Boots are difficult to draw. The lines of the newspaper on which they stand help to relate the shapes, the *outside* shapes, particularly the shape below the toe on the left and the underside of the other boot.

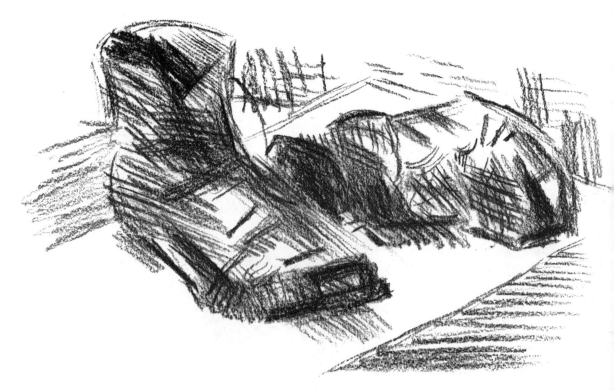

2. Charcoal is the softest drawing medium, except perhaps pastel. And the ease with which it can be erased encourages bold drawing. Some of the heavy shading here was deliberately put in to be smudged.

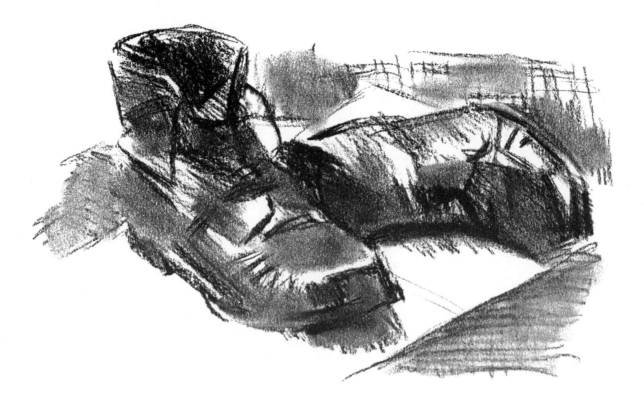

3. After smudging, the drawing looks more solid. But the smudged shapes are not clearly defined and clumsy.

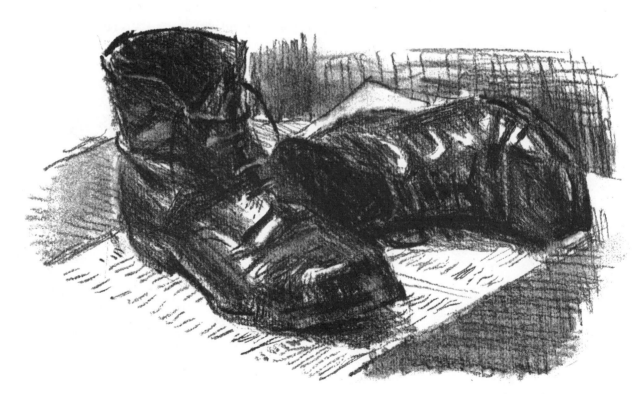

4. The finished drawing after applying heavier tones and smudging. Nearly every area where I smudged the charcoal has been varied by further drawing and line shading. An eraser has also been used for the bootlaces and some highlights.

Same subjects different techniques

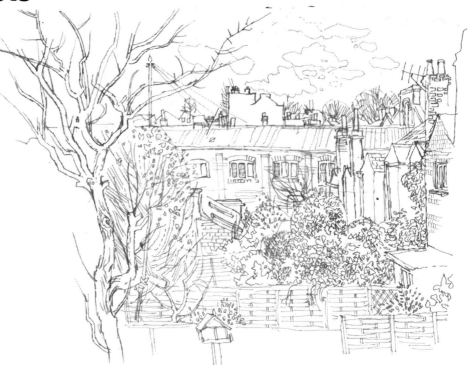

Hard Pencil (H). There is no attempt here to show light and shade or to differentiate between dark or light local colours. By the use of more or less open textures some variety of tone can be achieved.

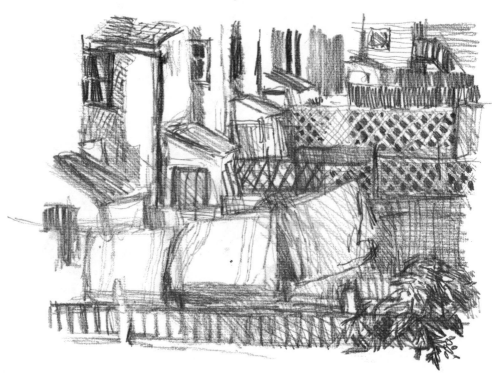

Soft pencil (2B). Notice the sparing use of the deepest tones, the changes in the strength of line, the openness of texture and the different directions of the shading.

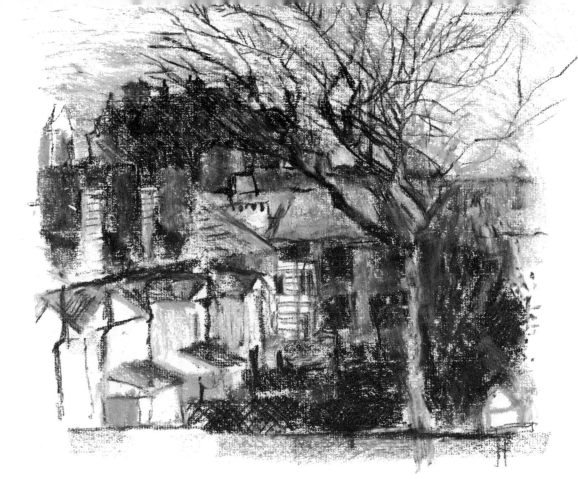

Soft wax pastels—black, white and grey. Very rich, painterly effects can be built up by the use of several tones of crayon on top of each other. Some scraping has also been used here.

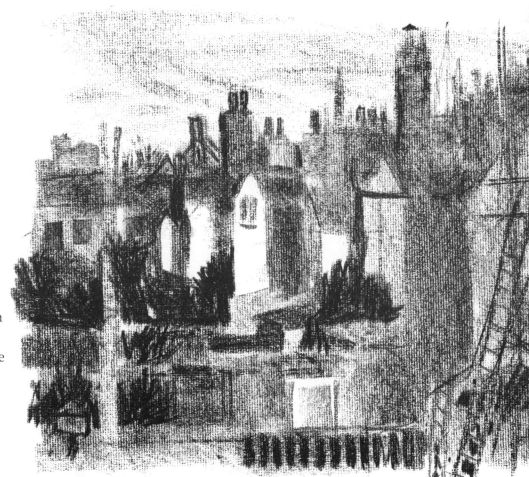

Wax crayon. This drawing was made on ribbed paper, and for most of it the crayon was laid flat. The greatest contrasts are confined to one area, which gives a sense of colour and light.

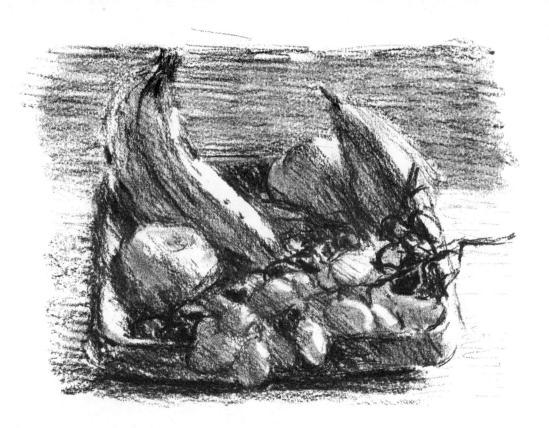

Charcoal. Rubbing and smudging have been used to create some of the tones in this picture, but they are varied by the addition of direct crisp drawing and shading.

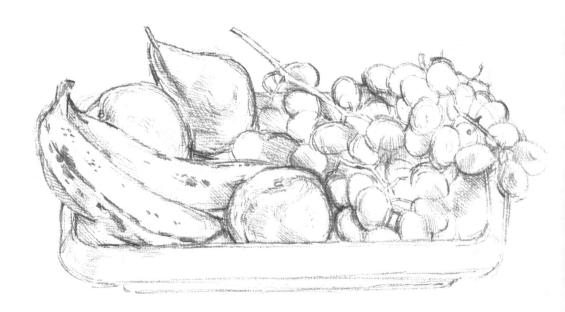

Pencil (HB). This drawing concentrates on line treatment, making no attempt to reproduce full light and shade. The direction of the shading helps to explain the shapes.

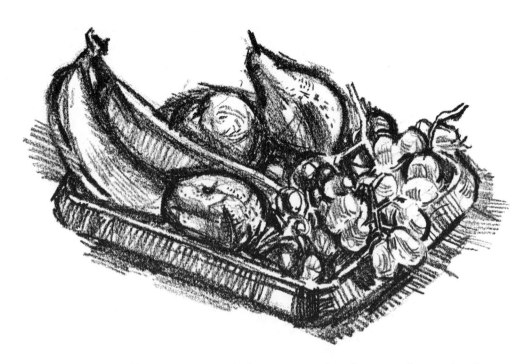

Chinagraph pencil. Although deep in tone this drawing also maintains a linear quality. Its approach is similar to that of the pencil drawing on the opposite page.

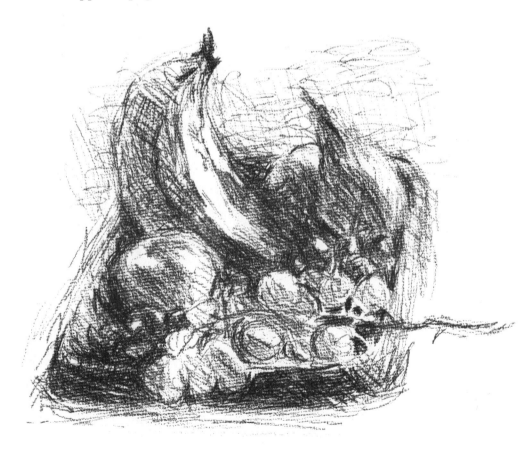

Conté crayon. This is a very free drawing and a good example of following the advice given on page 47 that the darkest tones should not be confined to small areas.

Four views from the same window. Slight changes of scale and direction result in four entirely different compositions.

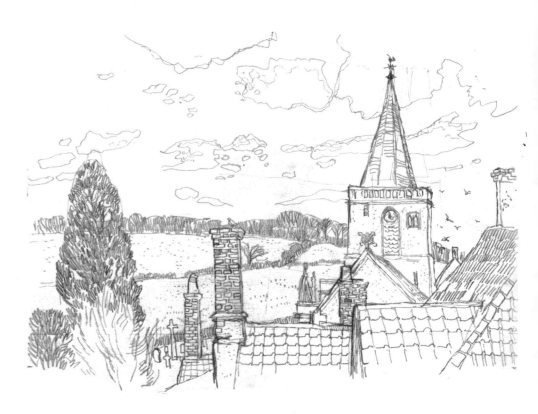

Pencil (HB). A line drawing without tones or shadows. The textures of trees, branches, leaves, tiles and bricks add life and interest.

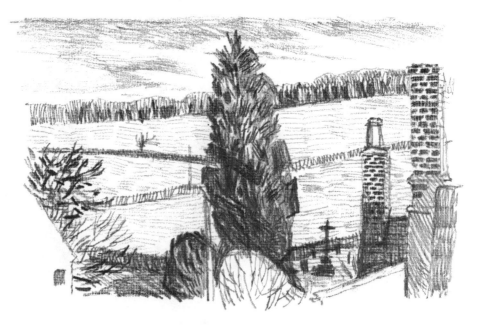

Pencil (6B). Using a much softer pencil, tone can be introduced while still emphasising the same textures.

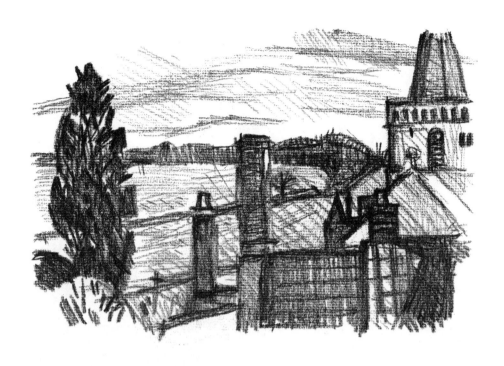

Chinagraph pencil. This drawing was done on coarse-textured, ribbed paper with a crayon unsuited to fine, detailed drawing. So the shapes have been simplified and bold tones reinforce the pattern.

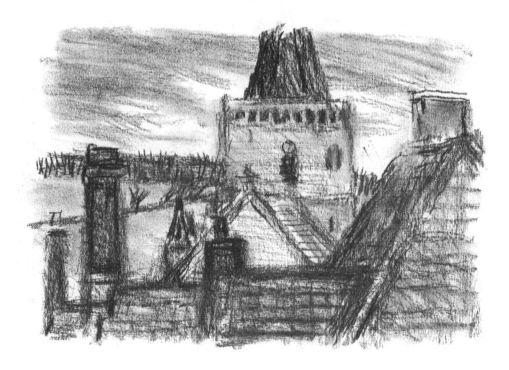

Charcoal. Smudging has been used freely here, but varied by direct drawing. Although there is less detail than in any of the other drawings in this group, this is perhaps the most satisfying of the four.

Three Conté drawings of a saucepan, milk can and colander, differently arranged and differently treated.

1) A heavy, line treatment, emphasising verticals and horizontals. Light and shade is also brought out in line—rather like a scaffold around the objects.

2) A simplified flat, tonal drawing, made by laying the crayon on its side. The highlights were left white—not picked out with an eraser.

3) A drawing concentrating on tone, where the shading follows the form of the objects. A strong background tone gives atmosphere to the whole drawing, and makes the highlights on the metal (which are the white paper itself) seem a positive element.

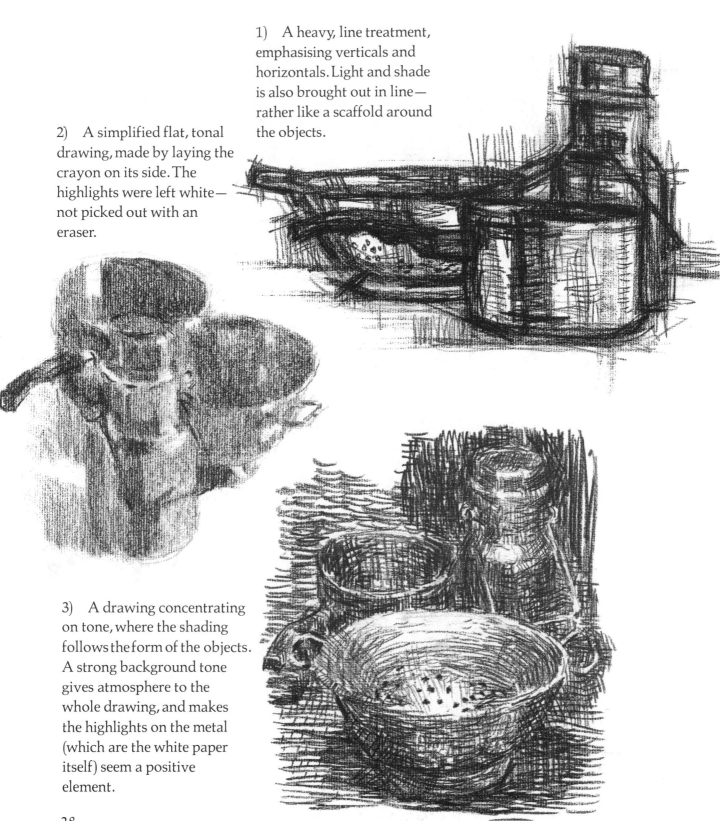

Two charcoal drawings on smooth cartridge paper of an old feed-cutter in an apple orchard. The drawings show the versatility of the medium.

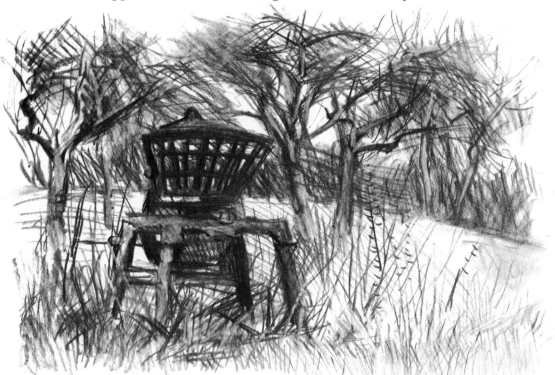

In the first I used smudging to spread and lighten the tones and an eraser to pick out light—on the tree trunk, for example.

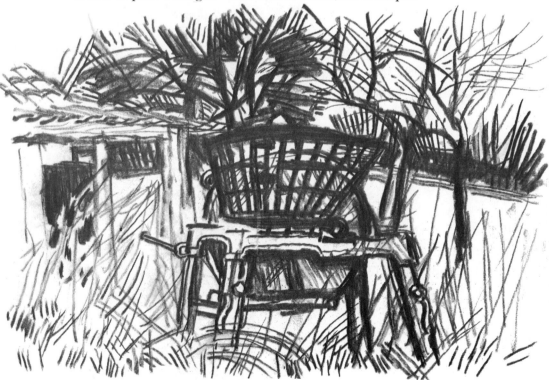

In the second, the charcoal was used firmly throughout, but some sticks were thick and blunt, others thin and pointed. This gives the drawing quite a wide variety of tone and weight.

Seven drawings with different pencils, of my right hand, some using a mirror. (I am left-handed.)

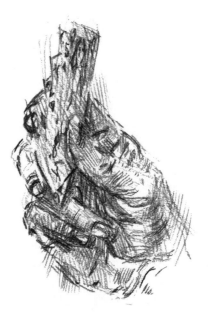

1) **3B pencil.** A free, loose drawing, which manages to convey information about tone, skin-texture and creases. The shading is varied, sometimes following the form, sometimes going across it.

2) **HB pencil.** A drawing consisting almost entirely of shading, and most of it running in the same direction.

3) **4B pencil.** Here only the heaviness or comparative lightness of line gives the illusion of modelling. (I have gone over the heavier lines several times.) This is a style of drawing suitable also for a woodcut or linocut.

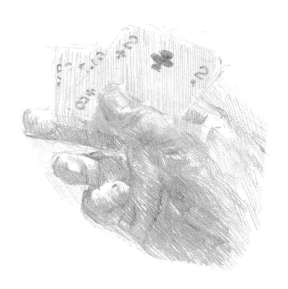

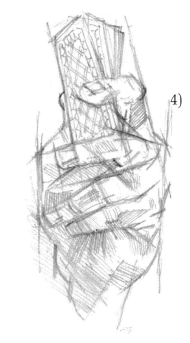

4) **HB pencil.** A simplified structure and shape is brought out in this drawing by straight lines. The modelling, not meant to indicate real light and shade, also explains the surfaces and structure.

5) **H pencil.** Here, I have concentrated on realistic light and shade. Modelling is through patches of short parallel lines in various directions. A background tone makes the lights stand out positively.

6) **B pencil.** The solidness of a hand is brought out in this drawing, which does not concentrate on detail.

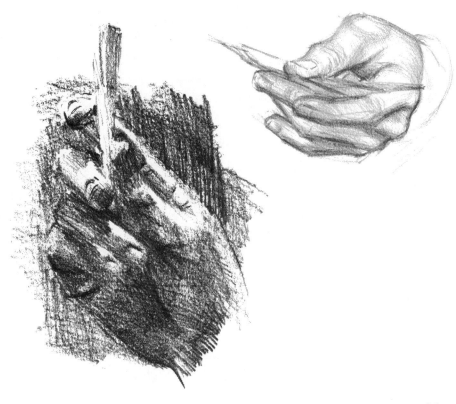

7) **6B pencil.** This is a similar approach to 5 in terms of light and shade. But with the very soft pencil the tones are deeper, the treatment bolder and the modelling not linear.

Finished drawings different techniques

The next six drawings are complete in themselves; not preliminary or preparatory studies.

Except for the background, where I used a B pencil, the drawing below was done with an HB. I have dealt with the tones as methodically as possible—even overdoing, which gives the drawing a hard, mechanical look.

Charcoal is a technique where smudging is justified, but in the drawing opposite I have contrasted the smudging with crisp lines to add variety to the textures. I used my finger to smudge the charcoal, and an eraser to pick out highlights.

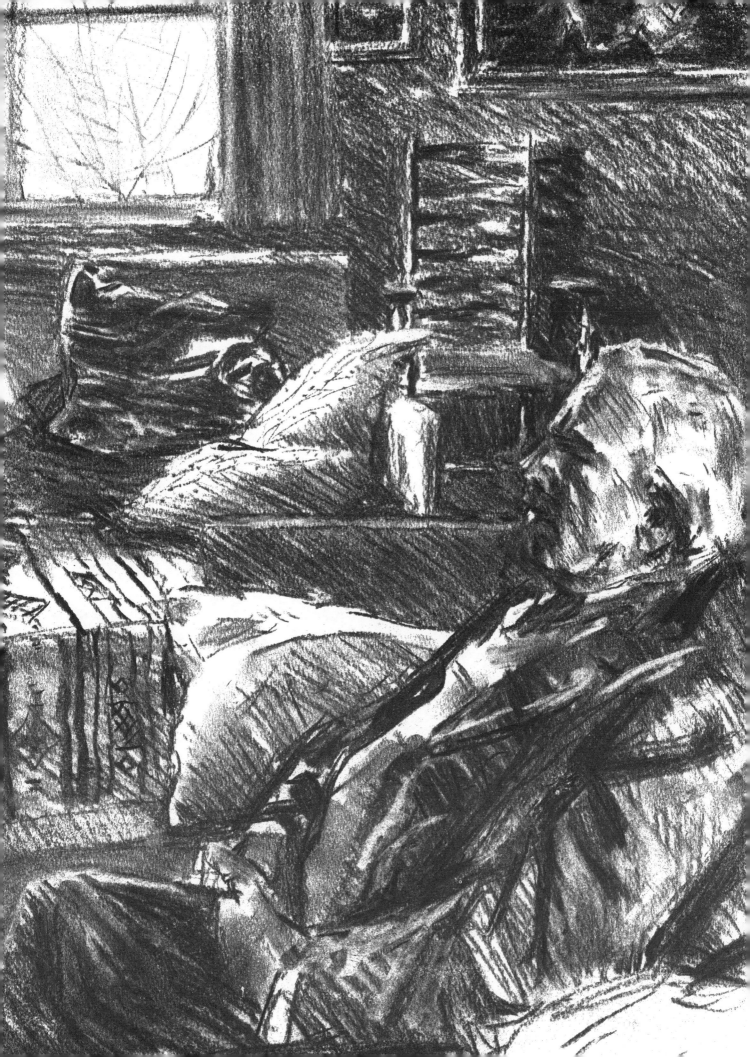

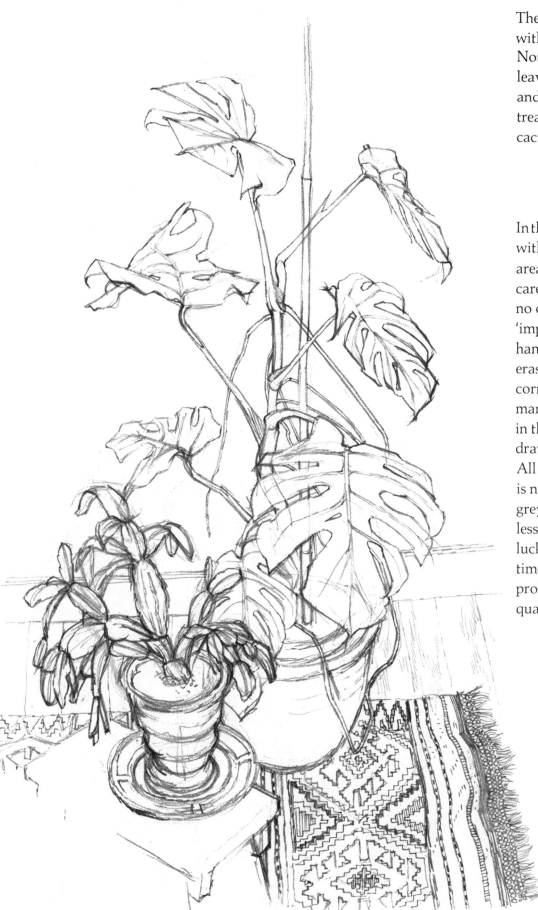

The drawing left was done with an HB pencil throughout. Note the sharpness of the leaves in the background and the freer, contrasting treatment of the foreground cactus.

In the self-portrait right, drawn with Conté crayon, every area is treated with the same care—or freedom. There is no over-emphasis on 'important' bits—face and hands, for example. No eraser was used; early corrections, and there are many, have become invisible in the general tone of the drawing.

All shading is linear. There is no attempt to get flat, grey areas. The drawing took less than an hour, but I was lucky. If it had taken three times as long it would probably have lost its 'free' quality.

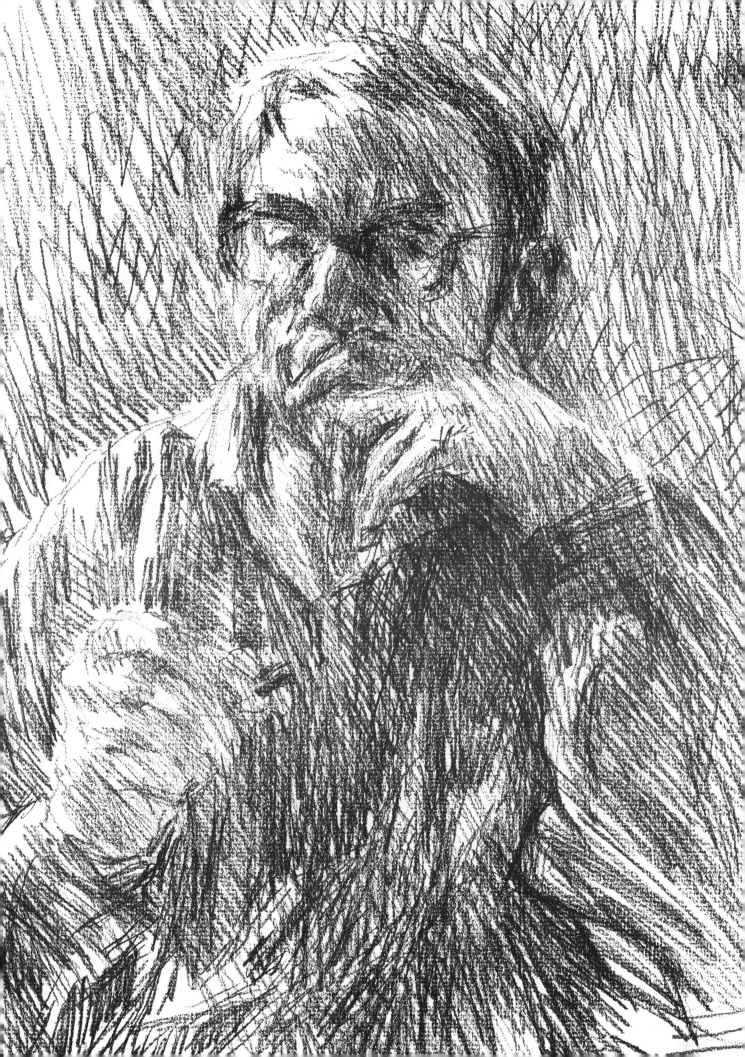

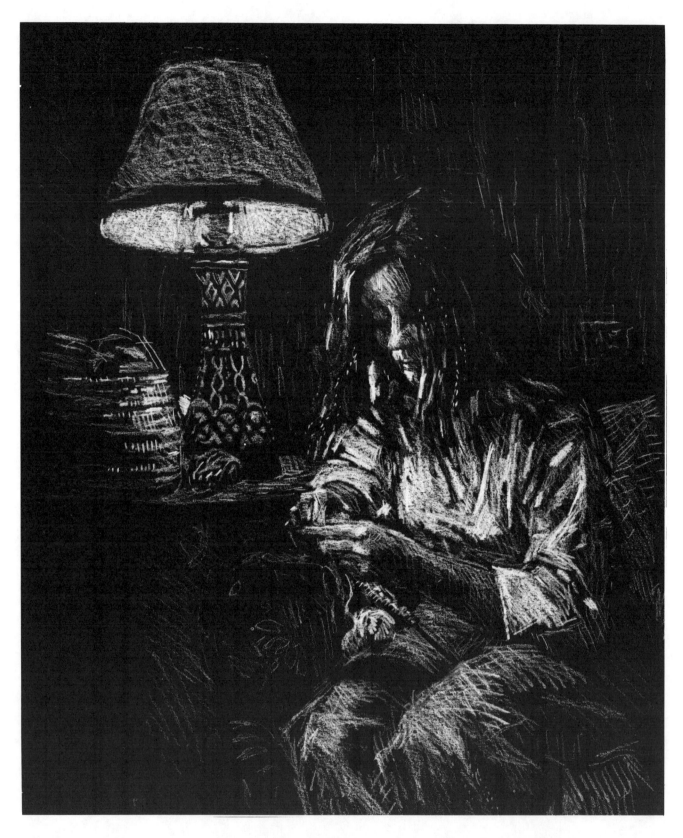

A drawing with white crayon on black paper. Realise that you draw the *light* in this technique. We are so used to drawing in dark on light that this requires a considerable effort. Allow the black to play its full part. Be sparing with solid white.

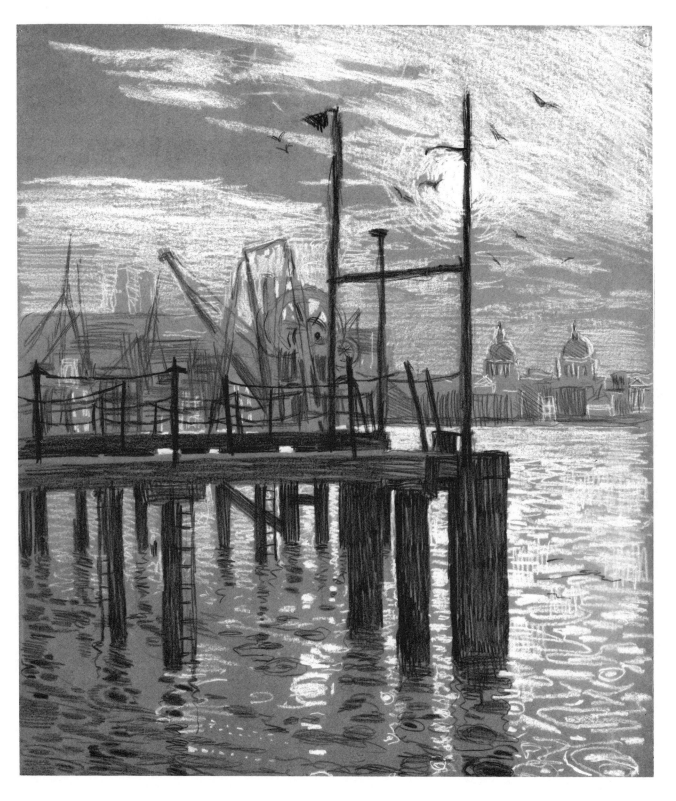

This is drawn with wood-cased black and white Conté crayons on smooth grey paper. Note how little solid black or white there is and how seldom black and white areas come together. Be economical. Let the grey paper do the work, and before you start a drawing like this, decide which areas would be best left grey—even though the grey will be the same shade all over.

Sketchbook drawings

The next six pages contain sketchbook drawings, which were preliminary studies for paintings. The notes on them about colour and tone are meant to give quick information in the most economic way. Economy is an ingredient of good, lively drawings; so sketches of this kind are often good drawings.

The first four were done in Greenwich, London, where I live. I used all of them for paintings—altering and simplifying for the final picture, but relying on them for information and a reminder of the subject's atmosphere.

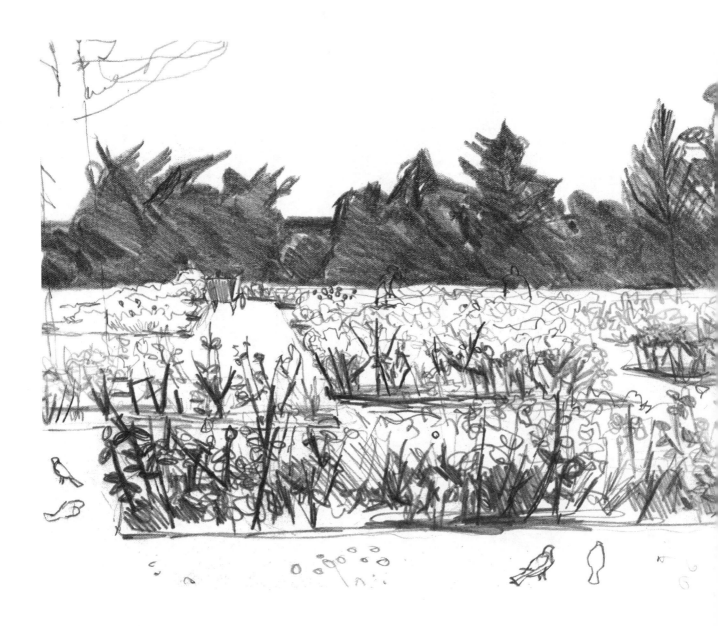

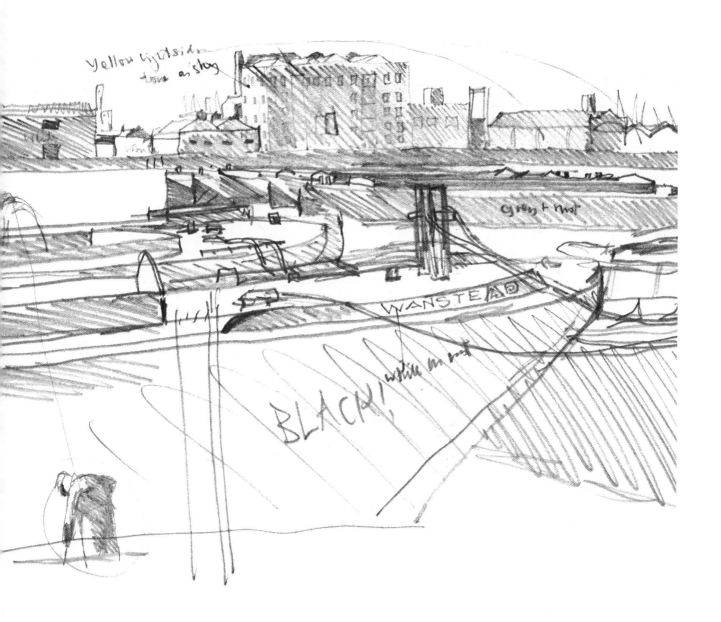

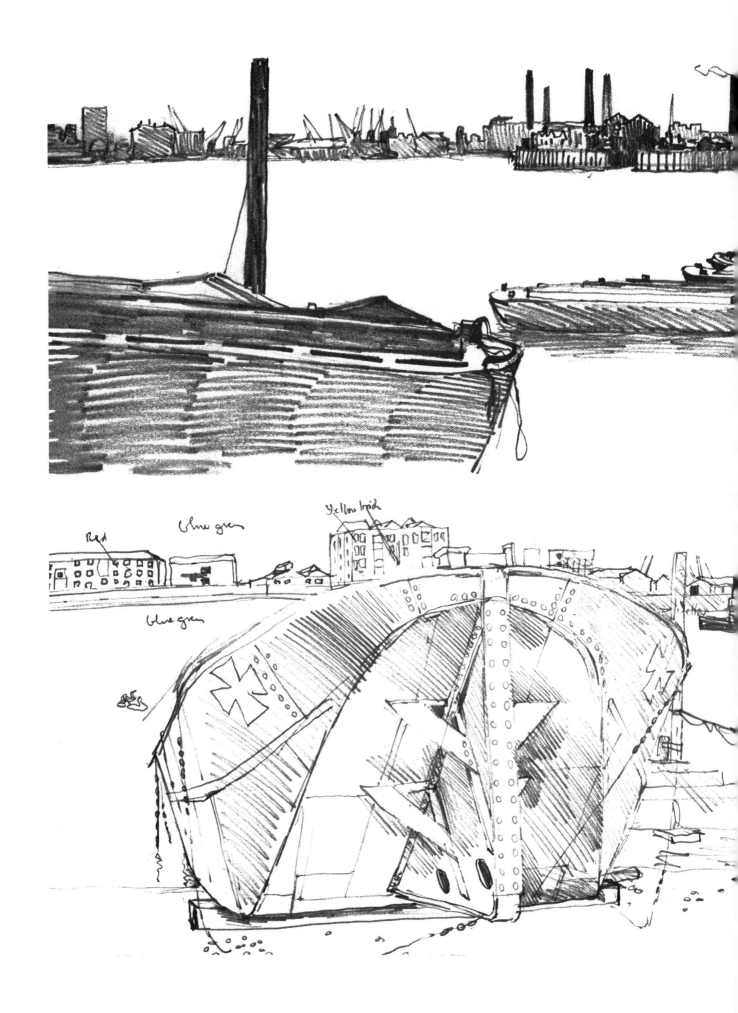

Red

blue green

Yellow brick

blue green

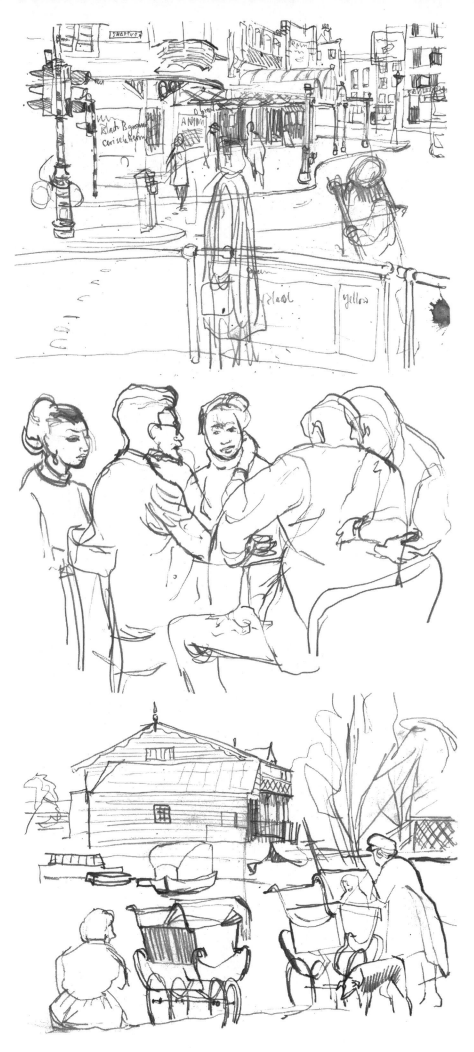

These three sketches all include figures, none of them aware of being drawn. The road sweeper in the right foreground of the top one literally swept past, but he became the centre and main interest of the subsequent painting. It is important to grab quickly anything which arouses your interest.

The people around the table were also in constant movement—leaning forward, turning a head, moving an arm. Although the basic grouping remained, each detail had to be drawn quickly. No going back, no afterthought was possible. The more quickly you have to draw the more carefully you need to select from what you are drawing. There is no virtue in quick drawing for its own sake, but there is virtue in simple drawing. Don't confuse the two.

In the third drawing the figures are less important than the building and centre foreground. In the painting I did from this drawing, I left out the women altogether.

41

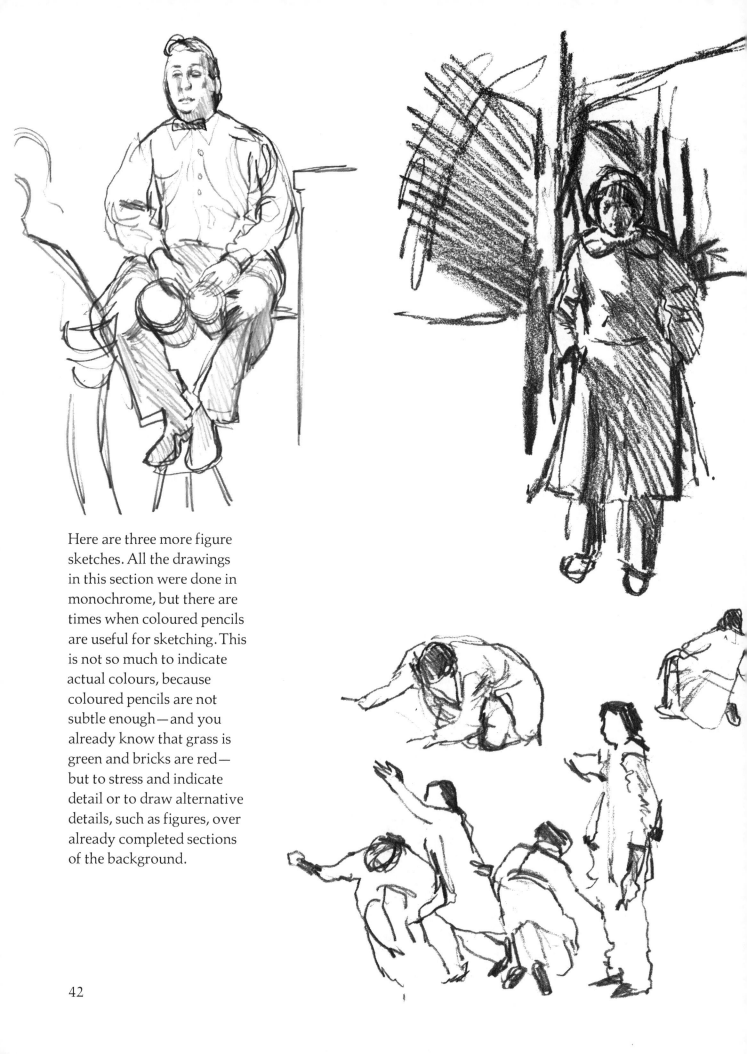

Here are three more figure sketches. All the drawings in this section were done in monochrome, but there are times when coloured pencils are useful for sketching. This is not so much to indicate actual colours, because coloured pencils are not subtle enough—and you already know that grass is green and bricks are red—but to stress and indicate detail or to draw alternative details, such as figures, over already completed sections of the background.

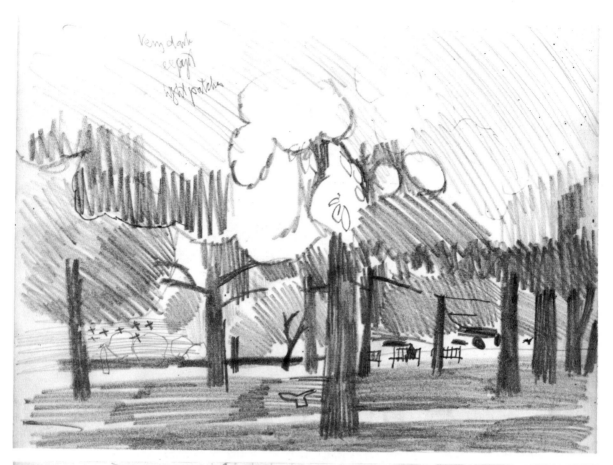

Above are two contrasting pencil drawings of near-identical subjects—
trees in a public park.

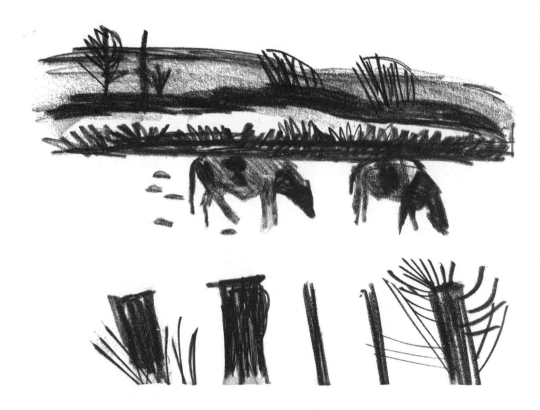

On this page also are two drawings from the same setting—looking into the fields beyond a country garden. The top one, in Conté, was drawn in winter. Even the white patches on the cows look dark compared with the snow on the ground. The other, a soft pencil drawing was done in summer. I was interested in the effect of looking into the sunlight.

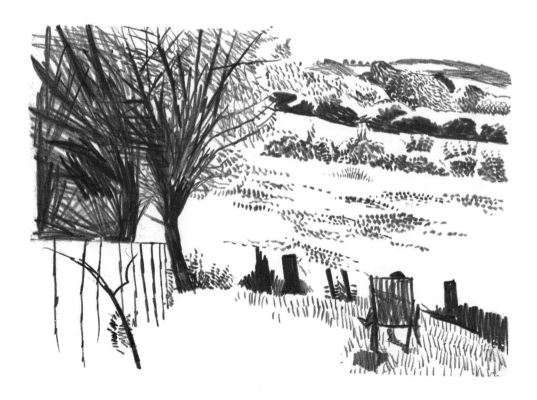

Dont's

Don't think that your problems are unique. The same pitfalls and mistakes wait for us all. The hints below may help you to avoid or overcome some of them.

Don't be afraid to start boldly. The first lines on white paper seem startlingly strong, but they will look far less so once the drawing fills out.

Neatness and art are not close relatives. Don't keep erasing 'untidy' lines. They also have meaning. Every line one puts down—one hopes— has thought and meaning.

Don't try to rescue a bad drawing ('Ah, well, when I've put some shading on it'll look better.') Start again. Once it has gone wrong there is nothing you can do.

Look at other artists' work, but don't copy it. Any original work is more creative and preferable to the most competent copy. You must find your own way and style.

Don't re-trace your original outlines to tidy them up. This can have two very undesirable results:

1) The 'tracing' line is usually dead. Your original line was probing and thinking—don't lose this.

2) Any modelling you have done within the object will have been in keeping with the outline. A new, heavy outline will flatten and neutralise your modelling.

In nature nothing has a line round it. The edge of any object, along which you put the outline, is the part furthest away from you. A heavy line along it will also bring the edge forward.

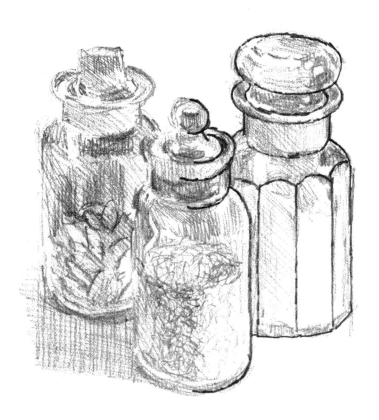

Be sparing with the deepest tones. You can't draw blacker than black.

Large areas of tone or shadow can be as dark as small ones. Don't exaggerate the depth of small areas and underplay the darkness of large one.

Your finger is a blunt instrument. Think twice before you use it to spread (smudge) pencil or crayon drawings. You will lose all subtleties.

Finally, don't get discouraged. Be self-critical, but do not expect too much from yourself. Progress is gradual. The more you learn, the more there seems to be to learn, but as long as you keep working you are making progress.

Presentation

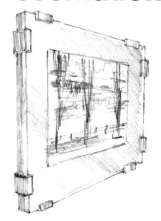

Mounting and framing makes work look more attractive and also helps to preserve it.

If you want a really professional framing job done, then take your drawing to a professional framer. You won't achieve the same result yourself, unless you are pretty handy with a mitre-block and a glass-cutter, and without a lot of practice; although there are now one or two good instructional books available, and you can buy do-it-yourself framing kits which you will find advertised in artists' periodicals. For mounting you need two pieces of card, one as a backing and one to cut as a mount (matt). They must be the same size. The larger the drawing, the thicker and stiffer the backing board ought to be. The diagrams will help to explain the following procedure·

First, cut your mount (matt). For drawings on white paper, a tinted card looks best—grey, buff, dull green, brown—the choice is yours. For drawings on coloured paper, white or ivory mounts look good.

Before cutting the mount, mark and rule lightly, in pencil, the exact size of the opening. The top and sides of mounts should be equal, the bottom a little wider, by ¼ to ½ inch according to the size of the mount. Even for small drawings the width each side should be no less than two inches.

Make sure that the opening in your mount is at least ½ inch smaller all round than the size of the drawing. If the opening and the drawing are too nearly the same size, the edges of the drawing have a habit of creeping through—which is unsightly, and may damage the drawing. Mount (or matt) cutting is a skill, but a steel straight-edge and a very sharp (I repeat, very sharp) knife such as a Stanley knife should give you tolerable results. Sloping edges to the mount are of course more attractive but a straight-cut mount is acceptable. There are mount-cutting blocks with fixed sloping blades on the market. They make it easier, but not as easy as the advertisements tell you.

With a pencil, mark the four corners through the mount on to the backing board, to determine the position of the drawing. Fix the drawing on the mounting board with Scotch tape or gummed paper hinges.

Bind the mount and mounting board with a strong fabric or plastic adhesive strip at the top.

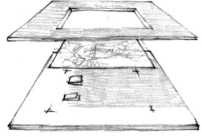

To ensure complete protection, tape a clear acetate sheet over the whole of the front of the mount.